Dedication:

To all the teachers, colleagues and students I have had the privilege of working with and learning from.

The Fundamentals of DRAWING

The Book that Proves Anvone Can Draw

Published and distributed by TOBAR LIMITED St. Margaret, Harleston, Norfolk, IP20 OTB, UK www.tobar.co.uk

This edition printed in 2005

© 2003 Arcturus Publishing Limited

All rights reserved. No part of this publication may be reproduced, stored in a retrieval system, or transmitted in any form or by any means, electronic, mechanical, photocopying, recording or otherwise, without written permission or in accordance with the Copyright Act 1956 (as amended). Any person or persons who do any unauthorised act in relation to this publication may be liable to criminal prosecution and civil claims for damages.

Printed in China

ISBN 1 903230 12 8

Contents

Introduction	5
First Stages	6
Object Drawing and Still Life Composition	39
Techniques	69
Aids to Better Drawing	78

Introduction

Learning to draw is not difficult. Everybody learns to walk and talk, and read and write at an early age. Learning to draw is less difficult than all that. Drawing is merely making marks on paper which represent some visual experience. All it takes to draw effectively is the desire to do it, a little persistence, the ability to observe and a willingness to carefully correct any mistakes. This last point is very important. Mistakes are not in themselves bad. Regard them as opportunities for getting better, and always correct them.

Many of the exercises in this book incorporate the time-honoured methods practised by art students and professional artists. If these are followed diligently, they should bring about a marked improvement in drawing skills. After consistent practice and regular repetition of the exercises, you should be able to draw competently, if not like Leonardo da Vinci – that takes a little longer.

Finally, do not despair if your drawings are not masterpieces. If they were, you would not need this book or any other.

First Stages

Before you start you will need to equip yourself with pencils, pens, charcoal, graphite and various kinds of drawing paper. Soft paper with a tooth or smooth hard paper are equally good, depending on the effect you want.

You will need to find an effective grip for your pencil and also get used to handling a drawing board and possibly an easel. Don't rush any of this, just experiment until you discover what works best for you. Once you are comfortable with the paraphernalia, you can begin to think about the business of drawing.

Also in this section you will find a series of exercises designed to introduce you to the basics and give you a grounding in various types of drawing. As you progress you will have to call upon the techniques these exercises teach, so practise them regularly and diligently.

MATERIALS

You don't need sophisticated drawing implements to be effective. If you are drawing for the first time, a B, 2B, 3B or 4B pencil, well sharpened, should be adequate. Buy a range of these and try them out, experimenting with their individual softness or blackness.

Later on you might like to try drawing with a solid graphite stick. This costs more than a pencil but lasts longer, and it's also very good when you wish to vary your strokes. Charcoal is marvellous for larger drawings and can be smudged or softened very easily. It also enables you to keep a light touch and still get a black mark.

A pen (0.1 grade or higher) is good to try out when you have developed some confidence.

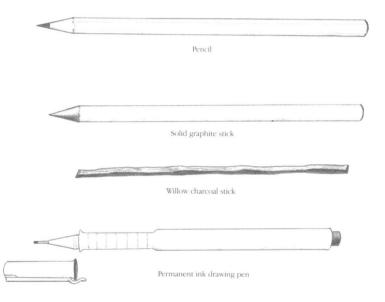

PAPER

All of the implements mentioned are used with standard cartridge paper. This comes in a variety of weights and textures and is available at art shops. Try out several different types so that you understand their respective merits. The advantage of smooth paper is that you can wire in greater detail and also draw smaller shapes. The advantage of a coarse paper is that the lines you draw on it look slightly broken, giving a textured effect and ensuring that you don't wire too small. Generally, the smaller the drawing the smoother and finer the drawing paper, nor implement, should be. Larger drawings require a corresponding increase in the textural coarseness of the paper.

A sketch pad is useful in the beginning because you can carry it around and draw whenever and wherever you like.

HOLDING THE PENCIL

Your inclination will probably be to hold the pencil like a pen. Try holding it like a brush or a stick. Keep the grip loose. You will produce better marks on the paper if your grip is relaxed and there is no tension in your hand or arm.

WORKING AT A BOARD OR EASEL

If you don't have an easel and are sitting with the board propped up, the pencil should be at about shoulder height and you should have a clear view of the drawing area.

The best way to draw is standing up, but you will need an easel for this.

There should be plenty of distance between you and the drawing. This allows the arm, wrist and hand to move freely and gives you a clearer view of what you are doing. Step back every few minutes so you can see the drawing more objectively.

Keep your grip easy and don't be afraid to adjust it. Don't have a fixed way of drawing.

USING THE PAPER

Try to work as large as possible from the beginning. The larger you draw the easier it is to correct. Aim to gradually increase the size of your drawing until you are working on an A2 sheet of paper and can fill it with one drawing.

You will have to invest in an A2 drawing board for working with A2 paper. You can either buy one or make one out of quarter-inch thick MDF. Any surface will do, so long as it is smooth under the paper; masking tape, paper clips or blu-tak can be used to secure the paper to the board.

LINES AND CIRCLES

In this first exercise you will learn the most fundamental cornerstone of good drawing; precision of hand and eye. Start by drawing the following geometrical shapes.

As you practise, concentrate on the point of the pencil exactly where the graphite comes off the pencil onto the paper. Don't be concerned if your attention wanders at first – just practise coming back to the point of the pencil. You will notice wobbles and blips creeping into the drawing whenever your attention strays. When you can keep your attention on the point of the pencil and no other thoughts and expectations intrude, you will find that your drawing will go smoothly. When the eye follows the hand exactly, the hand will perform exactly. Keep practising. Always start drawing sessions with five to ten minutes of practice.

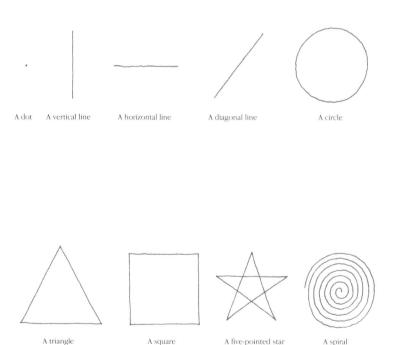

first stages

Control of the hand is a basic technique you must learn if you are to draw well. The more you practise the following exercise, the surer your line will be and the greater the accuracy of your eye in judging space and form.

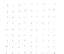

Draw a square of lined up dots, all the same distance apart and all in a

straight line.

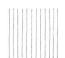

Draw a square of straight vertical lines, all the same length and all the same distance apart.

Draw a square of straight borizontal lines, all the same distance apart, all the same length.

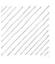

Draw a square of straight diagonal lines, all the same distance apart, of varying lengths.

Draw a square of straight diagonal lines, at the opposite angle.

When it looks fairly good, practise drawing it more quickly.

Don't rush these exercises. The value of them lies in concentrating your attention on the movement of the pencil on the paper. Repeat them until you feel sure and relaxed. If you feel tense, try consciously to relax.

3D SHAPES

to give the impression of depth and solidity in drawing, you have to use perspective or shading or both.

A basic illusion of three dimension and depth can easily be produced. Now try this next series of shapes.

1. Draw a square.

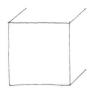

2. Add three more parallel lines.

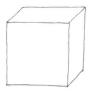

3. Join the ends ... and you have a cube. If your lines are accurate enough it is impossible not to see a cube.

4. Draw a diamond or parallelogram.

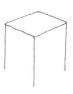

5. Add three lines of the same length and in parallel.

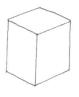

6. Join the ends – again, you have a cube!

As you can see, shading or tone helps to create an illusion of three dimensions or solidity.

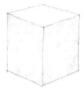

7. Shade the two lower sections of the cube lightly.

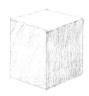

8. Shade one of the lower sections more heavily.

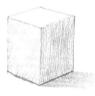

9. Add a cast shadow – this fades off from the darkest section in line with the floor or surface on which the cube is standing.

Now see what effect you can get by adding tone to a circle.

10. Draw a circle ... 11. Shade lightly just over half the

11. Shade lightly just over half the area in a crescent shape.

12. Shade more beavily a smaller area nearer the edge.

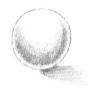

13. Shade the outer edge of this area more beavily still. Add a fading off cast shadow. Now your circle should look like a sphere.

ELLIPSES

Drawing ellipses is another of those necessities that the aspiring artist has to learn to do. Infortunately, there is no foolproof way of drawing them mechanically. You just have to practise until you become proficient.

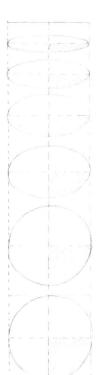

Ellipses are continuous curves and at no time do they become straight edged or create angles. Look at the three elliptical shapes below. Compare the two incorrect versions, which have almost straight edges or angles, with the correct version, which has neither.

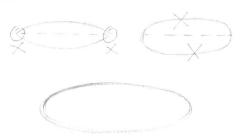

The column of ellipses shows what happens when a circular shaped object is viewed at various levels. At eye level a circle appears as just a horizontal line. When the object is lowered, the ellipse increases in depth while maintaining its width. Lower it further still and the circle will reappear.

You can practise drawing ellipses by placing a circular object – such as a plate or jug – at eye level.

The shaded area on each of the ellipses (left) is one quarter of the area of the ellipse bounded by the vertical axis and the horizontal axis. Your ellipse is incorrect if these quarters are not identical in shape. However, although each shaded area should be the same shape, it should be seen as a mirror image vertically, horizontally and diagonally. If you can observe this distinction when you come to draw an ellipse, then your drawing is more or less correct.

All shapes that are based on a circle – eg, cylinders and wheels – become ellipses when they are seen obliquely or from an angle.

Even more interesting than placing an object at eye level and drawing it, is to draw the wheels of a cycle or car from ahead or behind. In this instance the vertical axis of the ellipses will be long and thin. Changes in the width of an ellipse are dictated by the point from which you view the object.

BEGINNING TO DRAW OBJECTS

Having practised the previous exercises, now is the time to try drawing a real-life object instead of just copying diagrams or ideas. To begin, select a simple household object, like a cup or a bottle or a jar, anything in fact. Make sure it is not too complicated. Place it on the table in from of you and look at it carefully.

Notice its overall shape. Notice its height compared with its width. Notice the way the ligh falls on it. See its colour. See its texture. Is it reflective? Is it rounded? Is it angular?

What is happening when you look at an object in this way? Well, it is very similar to drawing it: you are considering the object as a shape or an area of colour or a form lit up. This how an artist looks at an object, although without actually asking these questions. In fact the less he thinks about it consciously, the more he sees. For a novice, though, it can be useful to ask these questions. Instead of seeing a jug or cup the artist sees a shape, colour, texture and form. This is the image a camera sees, and this is how it is received on the retina.

Now have a go at drawing your object. First of all just try to draw an accurate outline. It might be easier if you place the object at your eye level so as to reduce the problem o perspective.

The effect of this exercise, which can be repeated over and over again, is to gradually educate your hand and eye to work together. You are very good at seeing and you can trust that the appearance is correct. What gets in the way are the clumsiness of the untrained hand and the ideas about what you see. Don't try to interpret what you see, just see it.

CORRECTING AS YOU GO

When you have drawn the outline as well as you can, hold up the drawing so that you can see it and the object without having to move your head. Notice which bits are correct and, more importantly, which bits are incorrect. Then carefully redraw over your drawing more correctly without rubbing out the incorrect lines first. Carry on correcting the marks and lines until the drawn shape begins to look more like the object.

When you draw the correct line over the incorrect without rubbing out first, you are more likely to move to a better likeness. If you rub out the first lines, the chances are that you will draw the same incorrect lines again.

It doesn't matter how confused or messy the lines get because the eye tends to go towards the correct ones and ignores the incorrect ones. The eye likes comparisons and will tell you very rapidly if two shapes are not similar. The shape of the object itself is always the correct one. Trust your eyes – they are a very accurate gauge of shape, colour and texture.

low try drawing the same object in different positions. You might find some of these positions ifficult. Don't give up because you think you're making a mess. Stick at it. Just keep using the ame technique to produce more and more accurate drawings in outline. The more you pracise, the better you will get.

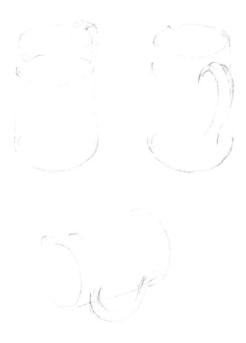

f a shape is incorrect, it is only a matter of discovering how. The cause can be one or more of few simple things. Do the lines need moving up or down, to the right or the left, closer ogether or further apart? Do the lines need to be smaller or larger, straighter or more curved? Is the angle correct, or is it perhaps too obtuse or acute?

Be ruthless with your drawing, and don't hesitate to change anything you see as incorrect. If you adopt this attitude at the very start, it will become a habit which will stand you in good tead later on.

As soon as you start to feel tired or bored, stop at once. Don't go against your own inclination. When you come to really love drawing you will find yourself carrying on regardless and tiredness or boredom will not be factors.

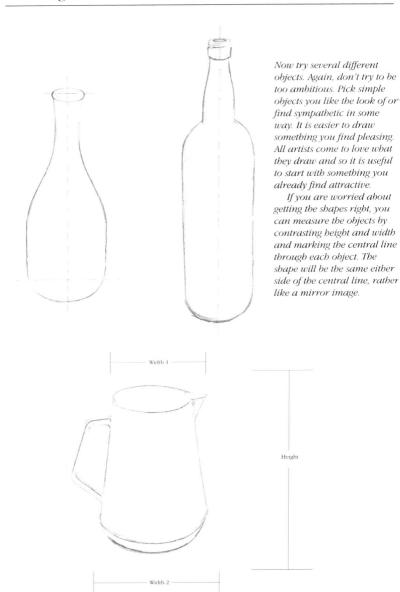

BASIC SINGLE OBJECTS

ractise drawing a range of objects of differing shapes to consolidate what you have learnt so far.

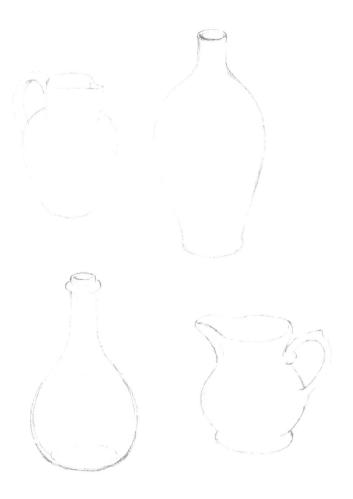

GROUPS OF OBJECTS

Now group two or three objects together, either of similar or contrasting shapes. Both ways can be fun. Relate the size, shape and proportion of each object to those of the other objects near it. You can then begin to see how interesting and complex drawing becomes.

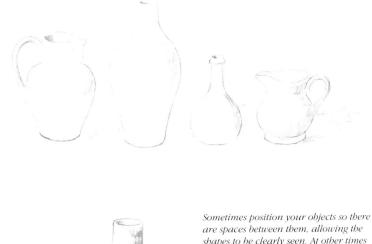

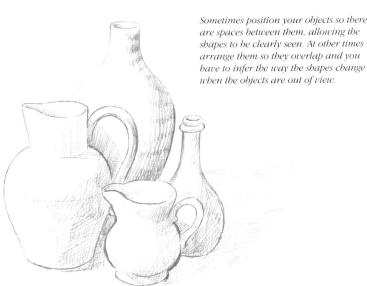

THE SHAPES BETWEEN

When drawing groups of objects, instead of always concentrating on the forms or shapes of your chosen items, concentrate on the space between them. This space also has a definite shape, bounded by the outline of the objects. By being aware of it, and treating it as part of your drawing, you can much more easily correct errors. If you get the spaces in between your objects right, the shapes of the objects themselves will also be right.

As you will begin to realize, in the visual world of the artist there are no empty spaces. Each space is something to draw. This also increases the interest in seeing.

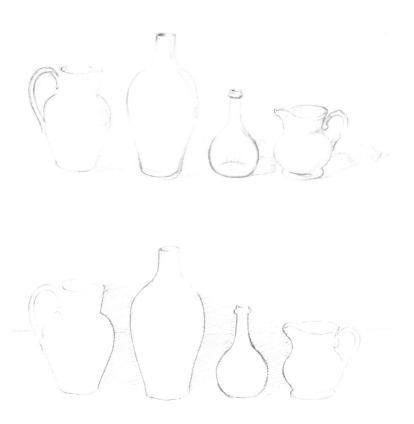

IDENTIFYING THE SOURCE OF LIGHT

The type of shadow that an object throws varies depending on the direction of the source of light. A simple way of learning about shadows is to arrange an object at various angles and note the differences. A lamp is an ideal of source of light for this exercise, enabling you to move the objects around to produce a maximum variety of shadows.

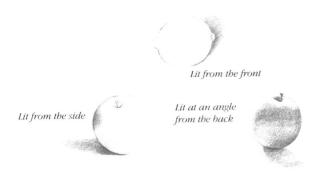

Here, notice how the apple with the light full on it and the apple silhouetted against the light look less dimensional than the apples lit side on.

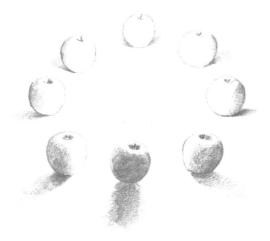

ARRANGING OBJECTS

When you have practised drawing groups of objects, spend some time just arranging objects into groups. The idea is not to draw them. Just arrange them, look at them carefully, see the shapes and patterns they make and then re-arrange them into different compositions.

The arrangement of sbapes within sbapes gives interest to this composition, as does a sense of confinement of the major elements of this meal in the making. The glassy eyes of the fish fix the viewer reproachfully.

Objects placed in close proximity look different as a consequence, as in this example of a jacket placed over the back of a chair.

You will find still life arrangements all around you, wherever you go. Someone has thrown a coat over a chair. Someone has laid a table for dinner. The shapes of glasses, plates, cutlery, not to mention details such as flowers, napkins or groups of condiments, form different patterns and designs, depending on whether you are seeing them from above or from sitting position or even from table level. Once you become aware of such possibilities, your eye will start to look for composition as it happens naturally.

METHODS OF MODELLING AND SHADING

Hatching, or building up tone, is the most conventional way of showing the effects of light and shade. To make it effective, you need to practise. Start by producing strokes all in the same direction, about the same length and evenly spaced. Don't try to rush this. Areas can be hatched very rapidly and with great accuracy, but this takes practice. Start slowly. Build up speed.

There are various methods of hatching:

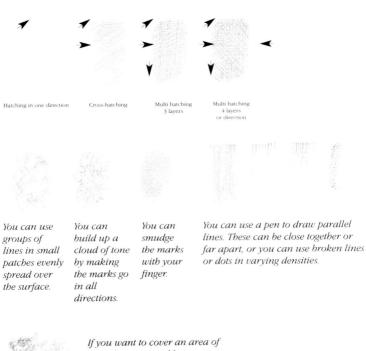

If you want to cover an area of your drawing quickly, you can use a broader stroke, achieved by using the side edge of the lead.

SIMPLE PERSPECTIVE

Perspective is very important if you wish to make a drawing appear to inhabit a three-dimensional space. The rules are fairly simple, but there are many ways of contrasting the lines of perspective to give the right effect. Drawing from observation will help you to see how perspective works in fact. Here we look at three devices which help explain the theory.

Rule number one of perspective is that objects of the same real size, look smaller the further away they are from the viewer. Therefore a man of 6ft who is standing about 6 feet away from you, will appear to be about half his real height. If he is standing about 15 feet away, he will appear about 8 inches high. Stand him one hundred yards away and he can be hidden behind the top joint of your thumb, and so on.

The first diagram gives some idea of how to construct this effect in the picture plane. The posts apparently become smaller and thinner as they approach the vanishing point. The space between the posts also appears to get smaller. This image gives a good semblance of what happens in the eye of the viewer, and one can see the use that can be made of it to create apparent depth on the flat surface of the paper.

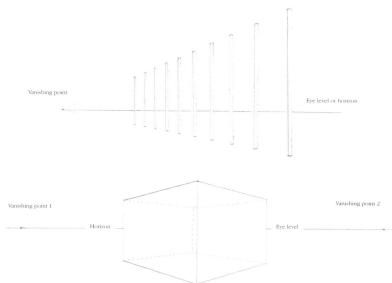

In the constructed cube alone the size is inferred by the height above eye level, which makes this appear to be the size of a small house. The dotted lines show the far side of the cube, invisible to the eye (unless the cube is of glass). It is noticeable that not all the lines are parallel to each other, as they are in the cubes drawn at the front of this book, but actually follow the rules of perspective which takes the lines to the two vanishing points. This device is very convincing to the eye, and it is the great re-discovery of the Renaissance artists (particularly Brunelleschi), which had been lost as an aid to drawing since Roman times.

AERIAL PERSPECTIVE

Another rule of perspective is that as an object recedes from the viewer, it becomes less defined and less intense, thus both softer outlines and lighter texture and tone are required when we draw an object that is a long way off. These techniques also help to cheat the eye into convincing the viewer he is looking into a depth when he is in fact gazing at a flat surface.

Look at the drawing below and note how the use of aerial perspective and a few simple techniques gives the eye an impression of space moving out into the distance.

The tree in the middle ground has less texture and intensity than the hush

The trees in the further distance are less well defined and more generalized in shape.

The nearest bush is still fairly strong in texture, in contrast to the tree.

The hills in the background are softer and fainter in definition.

Detailed and strong texture and definition in close foreground. Gradually the grass loses its intensity and detail as it recedes.

DRAWING PLANTS

When drawing plants, start by observing the growth pattern of the plant. Observation is the key, because once you can see how the plant grows and the forms the leaves and petals take, it is quite easy to draw it and to invent it.

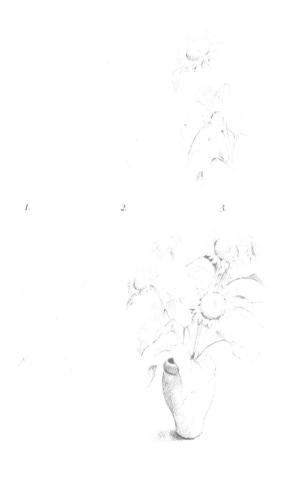

- 1. Build up from a very simplified growth shape, noting the basic shape of the blossom and the characteristic line and position of the leaves.
- 2. Draw in the main shapes of the petals and leaves in their simplest forms.
- 3. Now draw in all the details, including the slight differences in leaves and petals.

When you have completed this, try drawing a more complex group of flowers or leaves. You could use several examples of the same flower as we have done bere.

CHOOSING A LANDSCAPE

The easiest landscape to start with is what is outside your window. What you see will be helpfully framed by the window, saving you the task of deciding on how much or little to include. Going out into the countryside will give you greater scope.

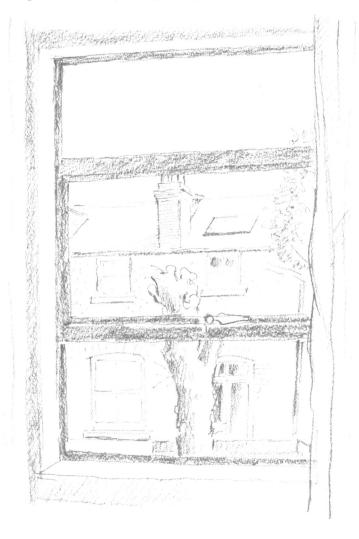

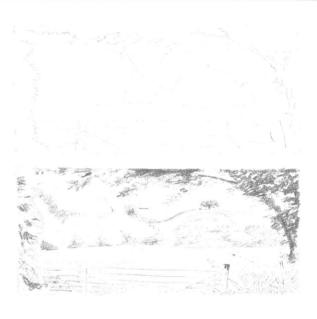

Once a scene is chosen, the main areas are drawn very simply. Noting where the eye level or horizon appears in the picture is very important.

Attending to these basics makes it much easier to draw in the detail later.

The hands can be used to isolate and frame a chosen scene to help you decide bow much landscape to include.

A card frame can be used instead of the hands.

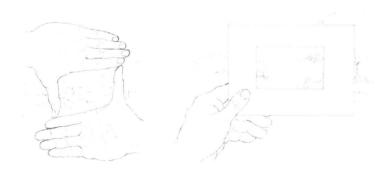

ANIMALS SIMPLIFIED

Drawing animals can be difficult. Rarely will they stay still long enough for careful study, although occasionally this can be achieved when, for example, a cat or dog is sleeping. Probably the best way to approach this subject is to find really clear photographs or master-drawings and carefully copy the basic shapes from these. You can see from the pictures of animals in this book how easily their main shapes can be drawn or even traced. Reducing the animal to simple shapes takes you half-way to understanding how to draw them. Once you have the outline the only problem is to draw in the details of texture and pattern: this does require more careful study.

Try copying the drawings of animals on these pages. When you bave done this, try applying the same simple analysis of shapes to illustrations of other animals.

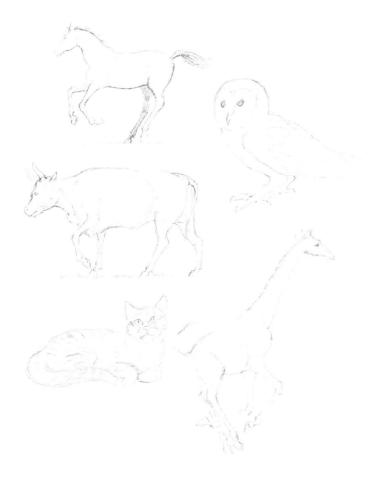

THE HUMAN FIGURE: PROPORTIONS

As you can see from the illustrations shown here, the proportions of both male and female are similar vertically but differ slightly horizontally. The widest area of a man is usually his shoulders, whereas in a mature woman it is usually the hips. Generally, but by no means universally, the male is larger than the female and has a less delicate bone structure.

The difference between a fully grown adult and a child is more dramatic, with the average child's head being much larger in proportion to the rest of the body. Usually the legs and arms are the slowest to grow to full size.

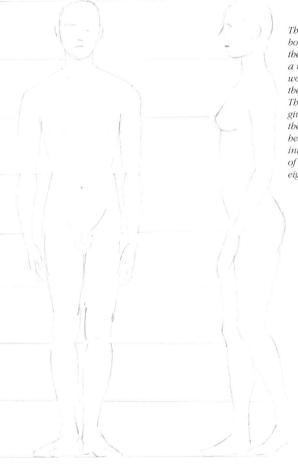

The illustrations on both pages show the proportions of a man and woman based on the classical ideal. The proportions given are based on the length of one bead, which fits into the full length of the body about eight times.

Not many people conform exactly to the classical ideal of proportion, but it is a reliable rough guide to help you draw the human figure. These proportions only work if the figure is standing straight and flat with head held erect.

Classical proportion is worked out on the basis of the length of one head fitting into the full height of the body eight times, as you can see below. The halfway mark is the pubic edge of the pelvic structure, which is proportionally the same in males and females. The knees are about two head lengths from the centre point. When the arm is hanging down loosely the fingertips should be about one head length from the central point.

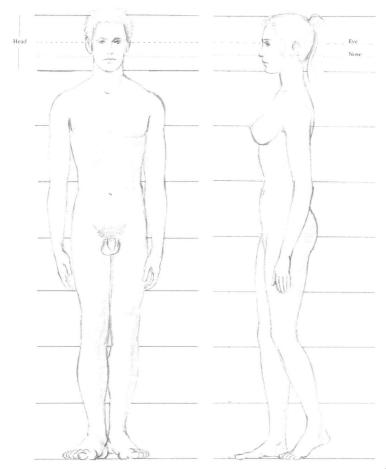

THE HEAD: PROPORTIONS

Most of the significant differences evident in the face are due to variations in the fleshy parts rather than in the underlying bone structure. However, the forehead, cheekbones and teeth can be more prominent in some people than in others. A child shows a smaller jaw, which is the last part of the bone structure of the head to develop.

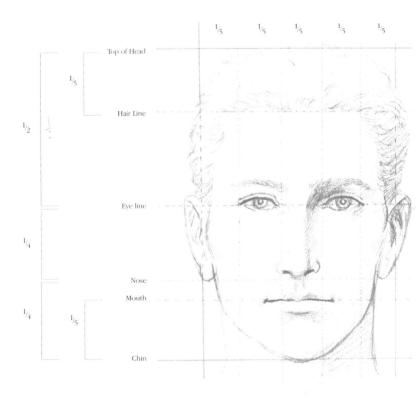

The main divisions proportionally can be clearly seen here. The eyes are balf-way down the head and the length of the nose is about a quarter of the full length of the head. The mouth is about one fifth of the length of the head from the base of the chin if we measure to where the lips part. The width of the head when looked at full on and in profile is about three-quarters of the length of the head.

When a subject is viewed face on, the distance between the eyes is one-fifth of the width of the head. The length of each eye from corner to corner is also one-fifth of the width of the head.

Unless there is balding, the hair takes up about balf the area of the bead. This is calculated diagonally from the top of the forehead to the back of the neck, as shown.

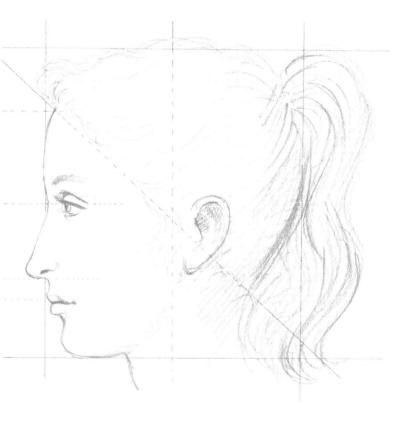

A common error when drawing is to put the eyes too close to the top of the head. This happens because the tendency is to look only at the face. Learning to take in the whole head as you work is vital if you are to capture the correct proportions of your subject.

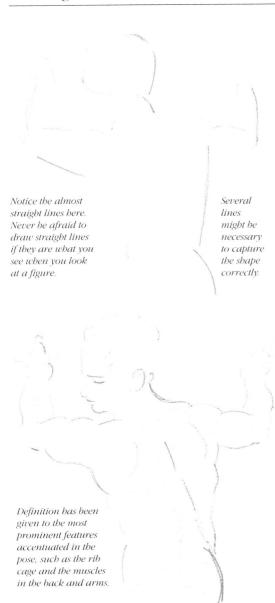

LOOKING AT FIGURES

When a beginner looks at the human figure, the greatest difficulty facing him or her seems to be where to start. There is so much to see that it can be confusing. Most artists try first to visualize the shape of the figure in its simplest form. That is, to see its almost geometrical character.

In the example shown here, the back is almost triangular until the point where it joins the hips. The arms, which are partially foreshortened, are simple, soft cylindrical shapes. The head is a slightly square egg shape.

If the artist can see these main shapes within a figure, it makes the task a great deal easier.

The basic shape and areas have been sketched in first. This is called blocking in the main shapes. In the second illustration, the shapes, although drawn in more detail. retain their simplicity. The lines are light and soft so that alterations can easily be made. This is the stage that professional artists work really hard at - correcting and re-correcting to get the shape right.

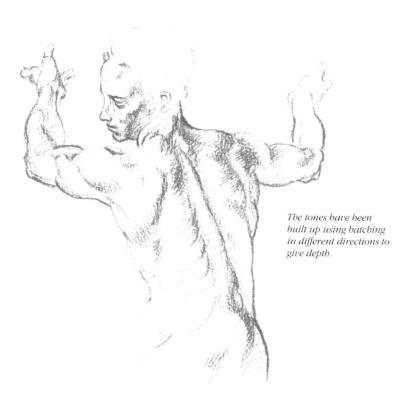

Tone is what gives a drawing its finished appearance. You will notice that in the second illustration a light tone has been applied in large areas. In the final drawing the darkest tone was worked in first. With the lightest and darkest tones in place, the final decision was to work out the variation in tone between these extremes. Usually two or three tones are all that are needed to finish a drawing.

It is difficult to keep viewing a figure as a whole without someone being there to constantly remind you, but it is important not to concentrate exclusively on one area. If you want to get good at drawing figures, make an effort to draw each part of the figure in some detail over a period of weeks or months. Drawing the same parts over and over again will only improve them at the expense of some other area of the body, and expose your technical weaknesses.

WHEN THE RIGHT SIZE IS THE WRONG SIZE

The drawings of objects and figures produced by beginners are usually rather small. This is due to the phenomenon of drawing what is called 'sight-size': the size a subject or object appears to your eye. As you can see from the illustrations here, if you let this be your guide, the size of that subject or object on the paper will be remarkably small. The margin for error at this size is equally small. Sight-size does have its uses though, and the beginner may use it for measuring the shapes of very large objects, buildings or landscapes.

So, to start with, always draw to the largest size possible. On your sheet of paper, the objects or figures should take up most of the space. This is true whether you are drawing in a sketchbook at A4, on a sheet at A2 or on a large board at AO. If you draw large you can see your mistakes easily and are able to correct them properly because there is plenty of space to manoeuvre.

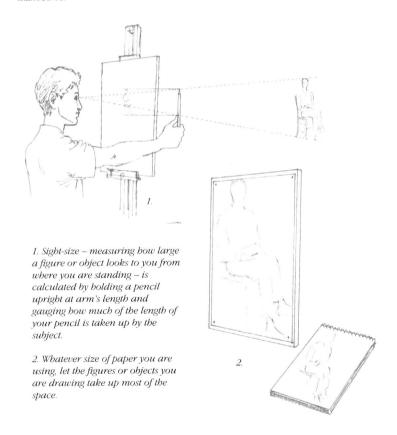

The bigger the paper you use, the bigger your drawing has to be. This may seem daunting but it will give you more confidence when you get used to it. When you draw large, you begin to worry less about mistakes and have more fun correcting them. Eventually, of course, you can learn to draw any size: from miniature size to mural size is all part of the fun of learning to draw.

When you begin to feel more confident, fix several strips of underlay wallpaper to a wall and draw heroic size – that is, larger-than-life size. You will find the proportion goes a bit cock-eyed sometimes, but don't let that worry you. Drawing at larger-than-life size can be a very liberating experience. It can also show you where you are going wrong technically. Once you have identified your particular tendency for error, you will find that correcting it is relatively easy, enabling your skill to take a further step in the right direction.

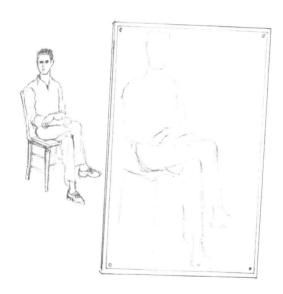

To start with you will probably find it difficult to draw large and will have to keep reminding yourself to be bolder and more expansive. It seems so natural to draw at sight-size in the beginning, but this has more to do with our natural self-consciousness and a mistaken belief that the smaller the drawing, the smaller the error. Once you discover how much easier it is to correct a large drawing, you will not want to go back to drawing at sight-size.

Object Drawing and Still Life Composition

In the last section you began to exercise your artistic talents by covering a wide range of drawing subject matter. Next you will be shown in greater detail how to expand upon and practise what you have learnt. In addition to consolidating your technical ability, you will be encouraged to develop further the art of looking.

When you have had plenty of practice you will find yourself noticing all sorts of interesting details in the objects around you, not just in the ones you attempt to draw. You will discover that, for an artist, the world is never boring because there is so much to see. Each time you look at an object, you will discover something new, no matter how many times you may have looked at that object before. This enhancement of awareness will lead to your perception deepening, enabling you to penetrate to the essence of seeing.

Don't worry about the quality of the lines and shading when you first try your hand at drawing this watering can. It is an advantage if the result is a solid and chunky looking object. Accuracy of shape is good but atmosphere is better still, so don't be afraid to be expansive in your pencil work. The more battered an object, the less precise in geometric terms do its lines have to be.

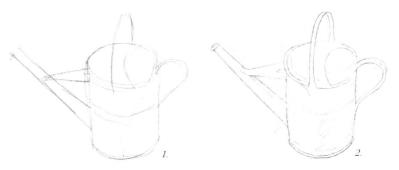

1. Draw in the main shape.

2. Block in the obvious areas of shadow using one fairly light tone.

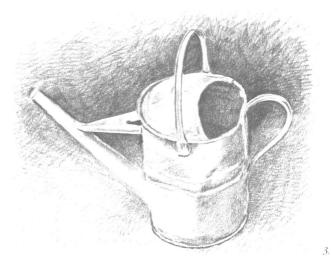

3. Now you can really go to work, giving plenty of texture as well as depth of tone to the object. The surfaces of the can will be worn and dented and have many small marks. Don't try to smarten them up. Let your pencil line reflect reality by keeping the texture gritty to give the effect of wear and tear.

With this wicker basket, your major problem will be how not to get lost in the complexity of what you're looking at. You need to discover the pattern of the weaving and decide how each piece of basketwork fits into the overall design. Once you have got the pattern worked out, you will not find the prospect of drawing it so daunting.

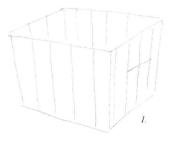

1. Draw a skeleton shape, outlining the basic structure of the main vertical struts and also the top and bottom of the basket.

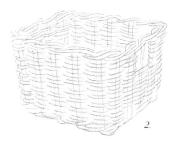

2. Now draw the general effect of the weave. Pay particular attention to the top and bottom edges.

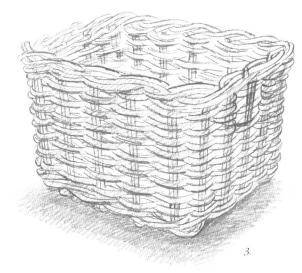

3. Lightly sketch in the areas of light and shade, including the shadow cast on the surface the basket is resting on - in this instance a tabletop. Lastly, emphasize any lines that show up more clearly and where there are darker tones or shadows.

You can measure the objects you draw, by contrasting height and width and marking the central line through each object.

I got these bits of old hardware from a builder's workshop. Their complex shapes pose a very good test of drawing ability. When you first try to draw them, you may find it is impossible to get the proportions correct. Don't worry, just keep re-drawing and correcting your mistakes. The aim of these exercises is not to get them right first time, but to redraw and correct, to discover how you see the objects when you get used to them. The geometry may be complex or simple but the combination of shapes is always a challenge, even for a professional. So keep trying.

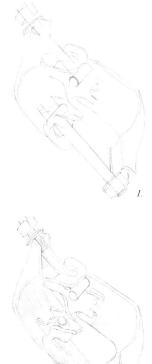

3. Finally, carefully put in the darks and lights of the reflections or textures so that the metallic quality comes across strongly.

- 1. In very clear and simple outline, draw the shape of each element within the overall structure, being careful to relate the size of each piece as accurately as possible. If you don't succeed in doing this, your eye will pick up on it and you will realize that your drawing is not convincing. If you take pains to get this first stage right the rest of your drawing will be much easier.
- 2. When you are satisfied with your outline, give the detailed shapes within the main structure greater clarity. By drawing them as crisply as possible you will capture the machine precision that differentiates mechanical objects from natural shapes. Don't attempt any shading before the technical aspects of your drawings are right.

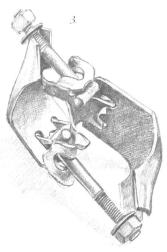

Where you have an object that is composed of different shapes, it can be worth measuring each part against the others in order to get the proportions right.

1. Draw the object in simple outline, making sure that each part will fit correctly with the others.

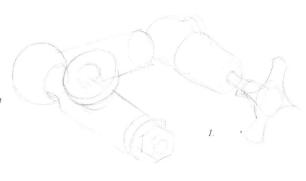

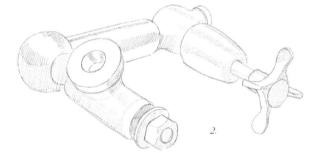

2. When the outline looks right, lightly put in the tonal areas.

3. Now deepen the tones that appear darkest on the object. Then gradually work up the in-between tones, leaving the brightest areas white. Don't forget to draw in the shadow cast by the object on the surface it is laying on.

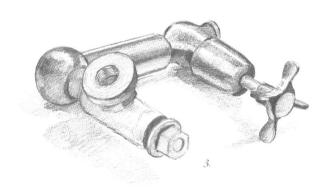

Over the next four pages you're going to practise drawing a series of different objects that vary in shape and function as well as materiality. Approach each subject in the way you have been shown in the preceding pages, concentrating first on structure and outline. Practice until you are sure of what each object looks like and how its structure can be shown.

Constant practice of drawing the structures of objects will help you to see in much greater depth and quality. Soon, when looking at objects, you will begin to pick up all sorts of subtleties that you may not have noticed before.

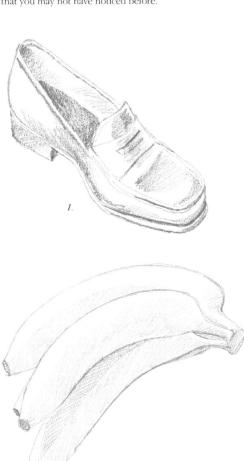

I have tried to reflect the material differences of these objects by using different grade pencils to produce variations in texture and tone.

- 1. This is drawn more coarsely in the tonal areas to emphasize the dark and light and give an effect of polished leather. I used a 2B.
- 2. These are drawn quite softly without too much contrast, using a harder B pencil.
- 3. This object shows the greater tonal contrast required for polished, metallic surfaces. For this I used a 4B.

Boots and shoes are satisfying objects to practise with, being rather characterful and also giving an impression of the absent wearer.

The examples of footwear shown below are less shiny than the shoe shown on the opposite page, being made from varieties of dull leather and kid, or suede. With these types of material, the handling of the tonal areas can be much looser to suggest the softer, non-reflective surface.

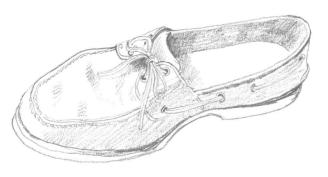

The rather wobbly line used here reflects the quality of softness characteristic of a moccasin.

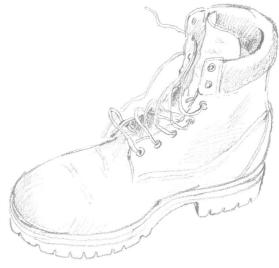

The sturdiness and rugged quality of this boot is achieved by not allowing the lines to be too smooth.

This next range of objects gives even more variety of texture and surface form. The headphones are slightly odd shapes and their form follows their function closely. The different types of stone share certain characteristics and yet are entirely individual.

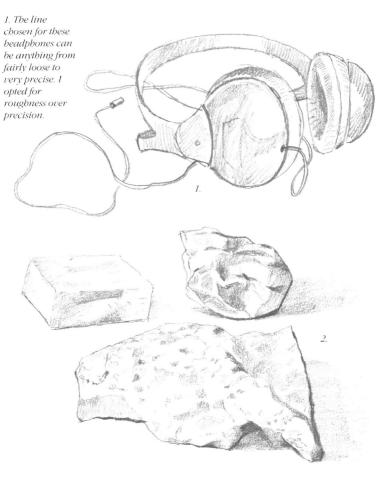

2. Correct drawing of form brings about the division of light and shade which enables the textural characteristics of an object to be shown. In these examples, those characteristics range from semi-transparency through chunkiness to density and crustiness.

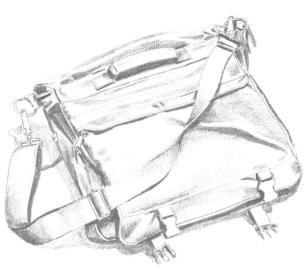

This satchel is drawn with auite dark shadows in a few places but is mostly fairly lightly toned to give the effect of a light-reflecting surface, although the material of the bag is black. If I'd felt it to be more true to the object, I could have put a tone of grey over the whole thing to indicate the colour.

The grain of the wood bas been described in some areas to make this toy look more realistic. It's important not to over-do this effect and let the surface colour take precedence over the form. A good trick which belps to get this balance right is to look at the object you are drawing through half-closed eyes. You will immediately notice which parts are dark and which light.

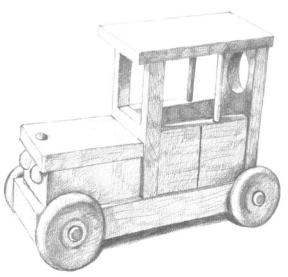

LOOKING AND DRAWING EXERCISES

Now give yourself a break from this regular drawing and try these two experiments which are favourite art school tests for new students. Both are limbering up exercises for what comes later.

1. Place a chair or stool against a simple background; just wall and floor. Now draw the outlines of the spaces between the legs and the struts and fill them in with shading or tone. The trick is to see only the shapes in the spaces rather than the object itself. Just go for the shape of the spaces between the parts and around the object. When you have done enough you will see the object in negative between the shaded spaces. Don't worry if you go wrong – have another go.

This exercise shows there are no empty spaces in any view of the world; there is always something, even if it is only the sky. This realization gives us tremendous freedom from trying to make objects purely representations of themselves.

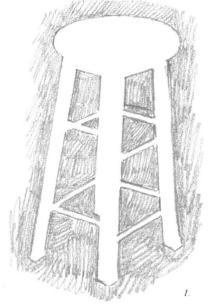

2. A more difficult test of looking and drawing is to take a sheet of paper, crumple it up, open it out a bit and then place it in angled light. Start with a small piece of paper slightly crumpled and progress to a larger sheet with more complicated crumpling. Carefully draw all the shapes, putting in the light and shade as you go.

This exercise is tricky to start with but does get easier with practice. The fun comes in seeing how many facets of the crumpling you leave out because you've got the shapes incorrectly aligned! You'll probably need three or four attempts at getting it about right.

The mere effort of trying to get your final drawing absolutely accurate will sharpen your attention to detail and help you to keep the overall picture in view. This will be invaluable later on when you come to tackle more difficult subjects.

STILL LIFE THEMES

When you have mastered the basics of structure and materiality, you can then consider devising a still life that incorporates different yet related objects, reflecting a common theme. A still life arrangement may present itself, as did the one shown here, incorporating a knife, worktop, pineapple and chopping board. Kitchens are good sources of this type of spontaneous still life, which look natural because it reflects an activity that you just happened upon and did not orchestrate.

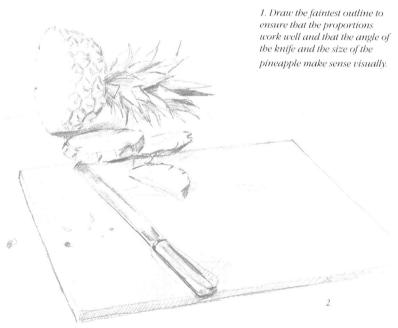

 Add texture and tone to give the picture more material conviction. There was not a lot of shadow in the arrangement, but the different textures belped greatly to give depth and weight to the objects.

STILL LIFE THEMES

Before you tackle a group of objects as a still life, it's a good idea to draw them as individual items but close enough on the paper to relate them. When you have done this, repeat the exercise, only this time with the objects grouped; you might want to arrange them so they overlap, as in the examples shown on the next page.

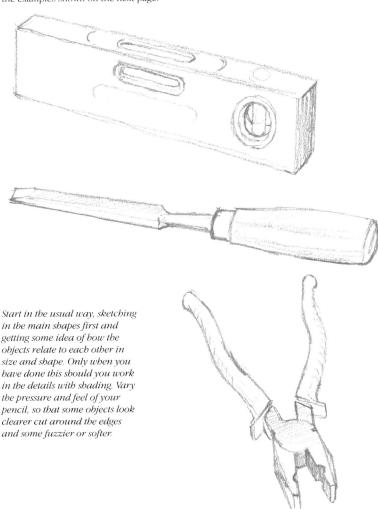

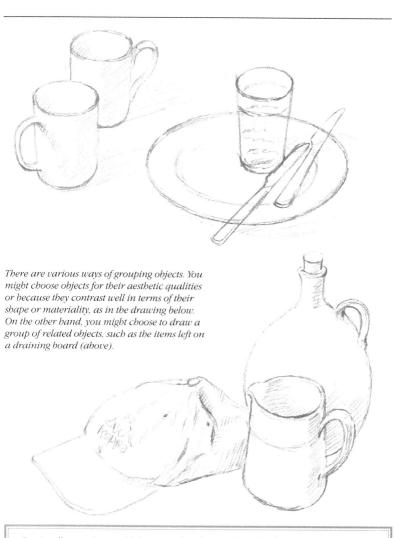

Continually experiment with how you draw lines and use hatching, and try to discover which approach produces the most effective result. No two objects require the same treatment. Try drawing the same objects first in very clean-cut lines and then in very soft wobbly lines. Now compare the results. There is no absolutely right way of drawing. Trust your own judgement: if a result interests you, that's fine.

The great still life painters – such as Chardin, Cézanne and Morandi – often made use of similar objects time and time again. Here are copies of three of Chardin's still lifes for you to consider.

Notice how all three arrangements use very similar objects with variations in their balance and composition. The contrast between the height of one object and the rest, the variation in size of objects, the grouping of shapes to counterbalance and contrast to create interest to the eye – these elements show the master touch of Chardin.

These jugs and glasses and pots and pans look deceptively simple, but Chardin's great talent with soft and hard edges, brilliant reflections and dark soft shadows creates a marvellous tone poem out of quite ordinary objects. Really there is no such thing as an 'ordinary' object. When the subtle perception of an artist is present in a work, everything becomes extraordinary.

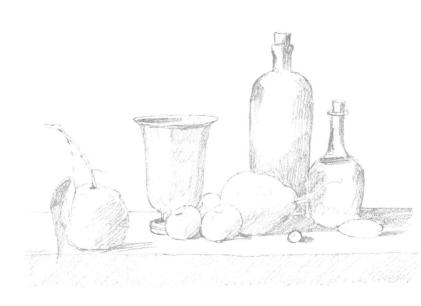

This composition relies for its effect on the different sizes of the objects and the spaces between them. The objects are almost in a straight line but there is enough variation in depth to hold the viewer's interest.

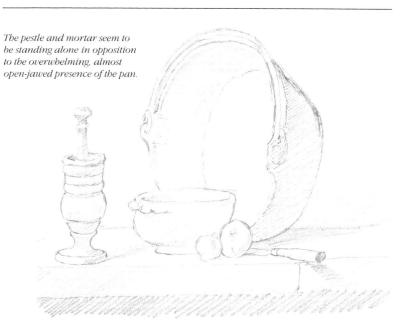

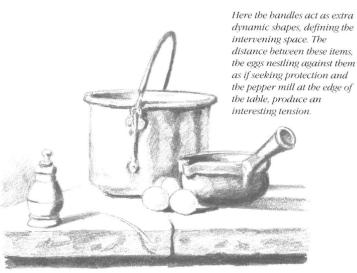

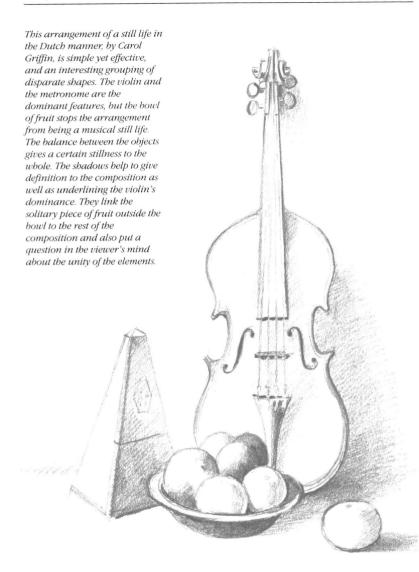

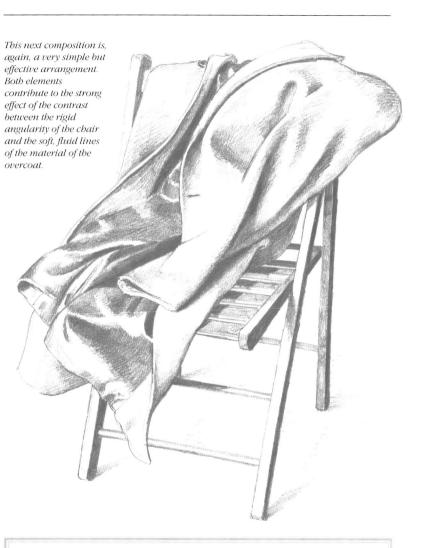

The more you try to draw objects and constantly make the effort to correct your work, the keener your own perception will become. In time you will draw with something approaching the quality that a practised artist appears to achieve with ease.

DIFFERENT ASPECTS OF STILL LIFE

All successful still-life arrangements exploit different aspects of the genre. In this series of copies of the works of professional artists, note how the objects are used either to repeat and reinforce the feeling of the group or, conversely, to interrupt and contrast the various elements. Either of these ways works depending on the effect you want to achieve.

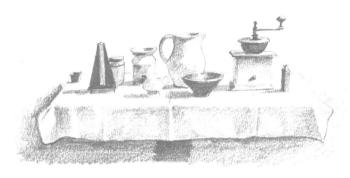

In this arrangement of a group of bard-edged objects, by Charles Hardaker, the interest appears to be in the variety of vertical shapes laid out on the brightly lit tablecloth with the table bidden beneath. This is a sharp, clear, lateral composition.

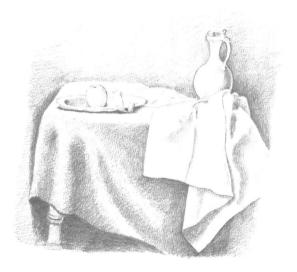

This cunningly arranged still-life, a copy of a Vermeer, is given its effect by the large light cloth folded over and draped across the corner of the table with the uneven tablecloth acting as a darker foil. The plate with a peeled fruit and the elegant jug contrasting against the soft shapes of the cloth add drama to the composition.

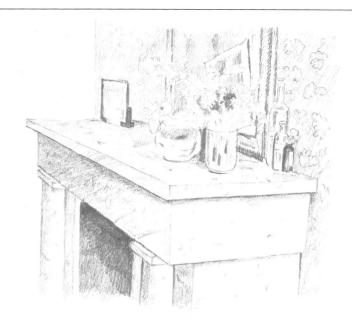

This copy of a Vuillard takes a very ordinary situation and produces an extraordinary piece of art out of it. It is a brilliant exercise in form and tone. The interest comes from the ephemeral objects set apparently accidentally on the solid, staid chimney-piece.

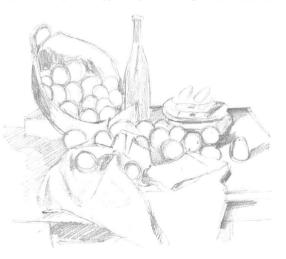

In this copy of a Cézanne, the bottle and folds in the tablecloth give assistance as a vertical element to the spilled abundance of fruit in the centre of the picture. The relationship of the structure of each object is submerged into the main shape and yet runs through the whole picture to make a very satisfying composition.

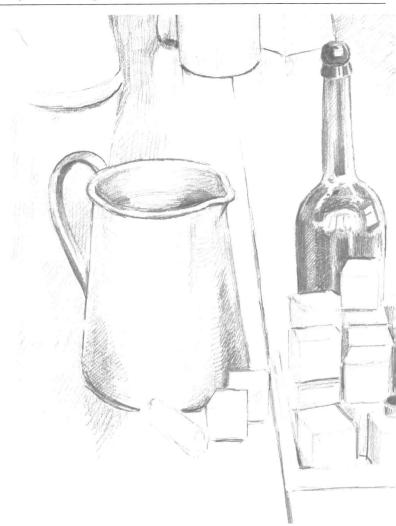

Place on a large table as many unrelated objects as will fit on it, then take a large sheet of paper and start drawing the objects, working your way across from one side of the paper to the other. When you have covered this first sheet, take another, move round the table and draw the objects you see, again starting at one edge of the paper and moving across.

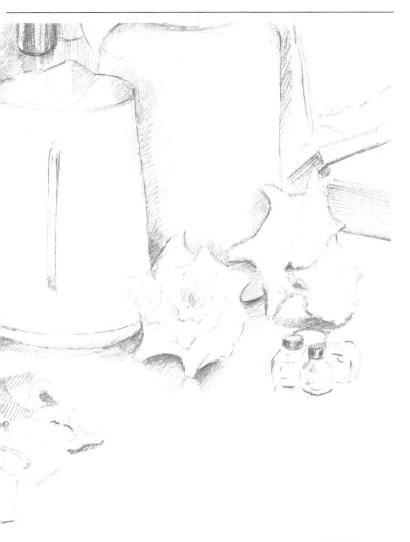

Each time you complete a page and move round to a new viewpoint, you will find that you have to relate the size of each object to the one next to it and include all objects in the background. Don't worry if you lose the composition, just keep observing and drawing. Don't concern yourself with the results either. The idea of this exercise is to keep you drawing for as long as possible, so that what you are doing becomes second nature.

STILL LIFE IN A SETTING

The last stage of still life drawing involves perspective and brings us naturally into the next section of the book. On this spread we look at still life compositions that incorporate the room in which they are set. This is a natural progression but, of course, involves you in more decision making. How much of the room should you show? How should you treat the lighting? Probably the best lighting is ordinary daylight and I would advise you to use it whenever possible. The extent of room area that you show depends on your confidence.

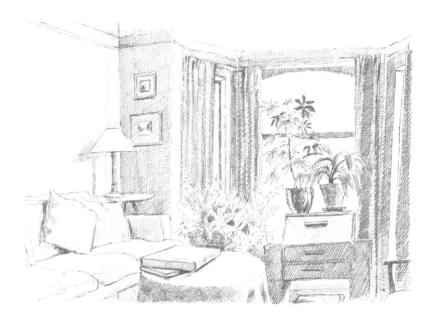

The interest in this drawing of one end of a room is with the objects set in the window and in various places around the room.

With an extended still life it is important to observe the details of the furniture and other main elements, such as the window frame. If your picture is to be a success, you must also be very aware of the source of light and make the most of how the shadows fall.

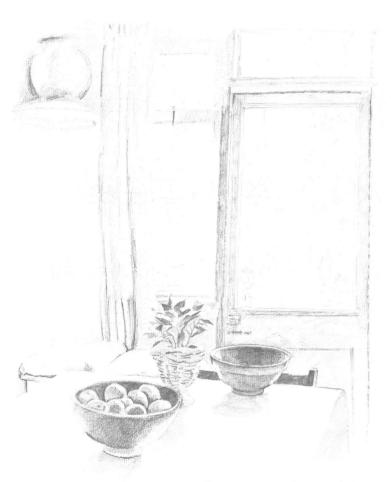

This arrangement makes more of a feature of the window, allowing the viewer to see outside and gain some sense of the garden beyond the window. Most of the objects shown are confined to the area of the table.

LARGE OBIECTS

Now we come to objects that cannot normally be considered as still life objects because of their size. You will have to step out of doors in order to draw them, and encounter the wider world. There is very little cosmetic design to a bicycle and the interest for the artist is in the unambiguous logic of its construction.

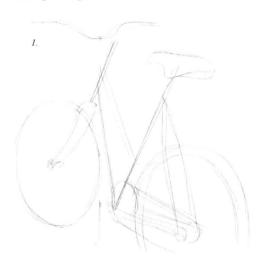

1. Make a quick but careful sketch of the main structure, including the wheels; this is another opportunity for you to look at ellipses (see page 16). Ensure that the long axis is vertical. Now check that the proportions and angles are correct.

2. Begin to build on this skeleton, producing a clear outline drawing showing the thickness of the metallic tubes and tyres and the shapes of the saddle, handlebars and pedal and chain areas. Be careful to observe the patterns of the overlapping spokes on the wheel.

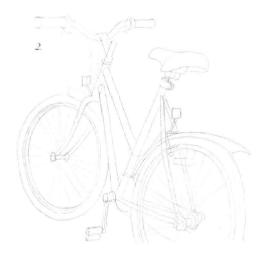

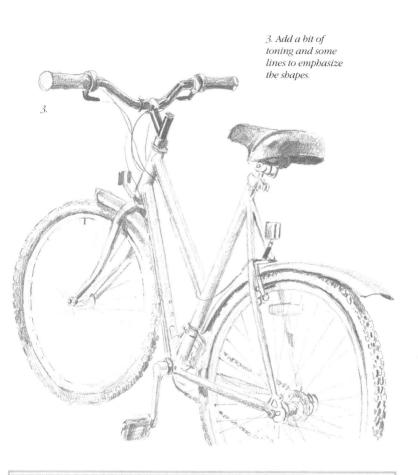

The main problem the artist encounters when drawing machines such as bicycles, motorbikes or cars is how to retain a sense of the complete structure without losing the proportions of each part. Don't try to be too exact with the details. Concentrate first on simply sketching the main structure of the machine. You will find this structure has a sort of logic to it, which is why it works as a machine. To get such a drawing to work visually you have to see the object as its designer might have envisaged it.

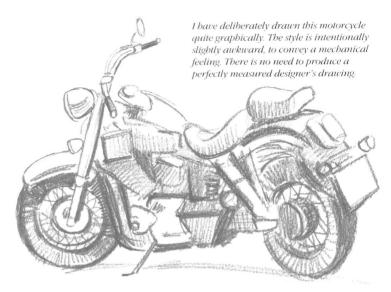

By comparison, the car is drawn rather loosely to allow the shine of the surface to work for the picture. Although you would never confuse this drawing with a photographically exact picture, it has enough consistency and attention to detail to allow the viewer to recognize the make and type of car.

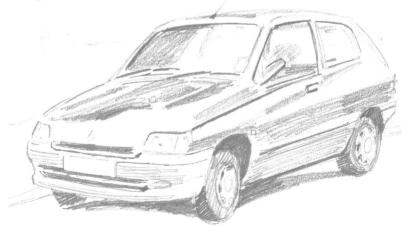

Here we have two large dynamic objects. The Jeep has a chunky sleek look and a soft line actually enhances the shiny but solid look of the vehicle. Cars are, of course, plentiful and do keep still, as long as the owner doesn't suddenly jump in and drive off while you are in full flight of creative work. The boat has a sharper profile and more elegant line.

Here, the overall light colour contributes to the illusion of sleekness. Tone has been used sparingly; some is needed to indicate the shapes but the reflected light from the water and the white painted hull and super-structure call for brightness and well defined lines.

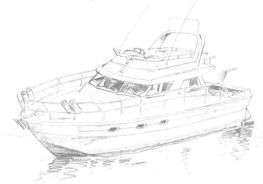

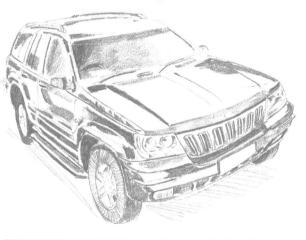

The slightly bulging shape of this rugged vehicle is given even more prominence by the angle. This viewpoint emphasizes the machine's strength and power, without making it look threatening.

An item of machinery can dominate a still-life composition, so long as the setting you choose seems right for it. A backdrop for a bicycle might be a hallway, a backyard or a garden, for example, or even the front of a house. A car would look at home as part of a street scene or centre stage in a garage with the door open. Such a scenario would give some interesting lighting, especially if there were other related objects close by. The possibilities are endless.

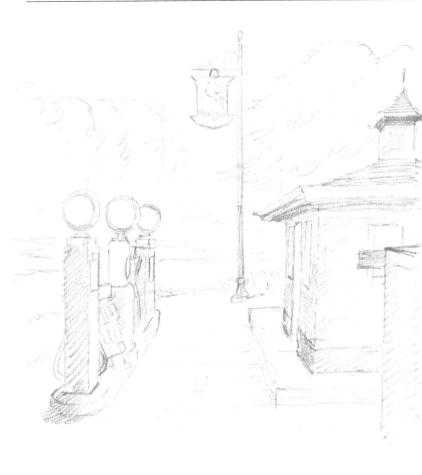

The style of your drawing can vary enormously and you should try to use different ways of handling line and texture until you find ways that suit your approach. Try sometimes drawing at speed without correcting much and sometimes proceeding very cautiously, making careful mark after mark, slowly building up a convincing effect.

However brilliant a drawing of an object might be, it is not actually that thing but an interpretation of it, a sort of visual reminder of what something might look like.

LARGE OBJECTS IN A SETTING

In both of these compositions the use of perspective is essential to their success. The styles adopted are also strikingly different, to fit their subject matter.

In the revised copy of an old petrol station at night, by American artist Edward Hopper (opposite), I have deliberately omitted the figure that is in the original. The drawing derives its power and its interesting atmosphere from the strong shapes and unusual lighting.

The drawing of a modern petrol-station (below) is very contemporary and quite different in feel and look from the copy of the Hopper. The petrol station looks like a drive-in supermarket. Everything about the image is sharper, pristine even, and the car is redolent of power and speed.

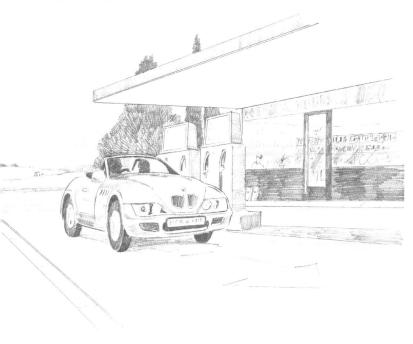

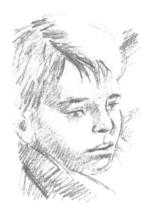

Techniques

In this section we will consider how certain technical details affect our view of a figure. Line, tone, texture and contrast work together to bring greater feeling, significance or just sheer enjoyment to the way we look at a picture. As you will see from the following examples, the techniques we use change the way figures work. Experimenting with techniques will increase your understanding of how to bring about the effects you want to achieve in your own drawings.

LINE VERSUS TONE

Each of the following drawings has been given different treatment with regard to line and tone. Different effects can result from the balance between these two technical elements.

1. This is primarily a line drawing, showing the outline of the form with only minimal shading to reinforce the shapes. The outline is sharp and definite, and even without the cross-batching shading it would still make sense.

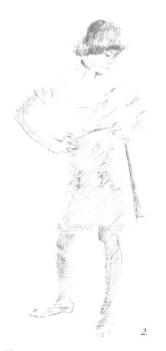

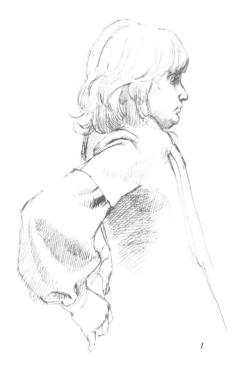

2. In this figure the outside edge is much less sharply defined but the impression of solidity is much greater. Standing with the light coming from behind, this figure was drawn almost without an outline. Blocks of pencil toning of various strengths give the main shape of the figure and only some details are outlined to give emphasis. The small areas of light which creep around the edges of the arms, legs and skirt point up the round solidity of the figure and stop it being just a silbouette.

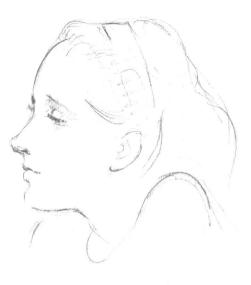

This profile is very loosely drawn with bardly any tonal work and not even a very firm outline. The lines of her head are a lyrical expression of her youthful enjoyment of life.

Contrast this technique with that used in the drawing below, where the head is heavily pencilled in with shadows.

Here the head is beavily pencilled in with shadows and vigorous tonal values. The dark tonal marks underline the atmosphere of brooding and the apprehension evident in his concentrated gaze. He appears to be considering something we cannot see

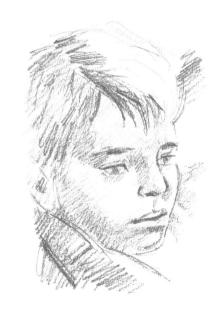

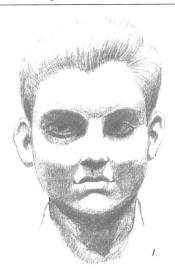

1. Lit from directly above, producing dark shadows around the eyes and under the nose and chin.

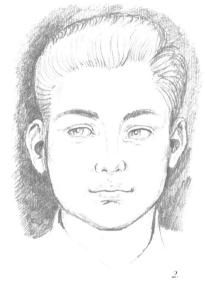

2. Lit from the front, flattening the shape, resulting in loss of depth but there is increased definition of the features.

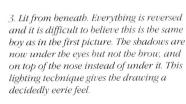

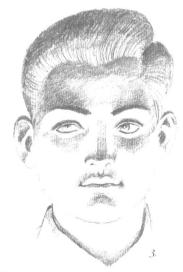

EXPERIMENTING WITH LIGHT

No matter what you are drawing, the light source is important. Here we look at the effect of different lighting on the same subject. Different lighting teaches a lot about form, so don't be shy of experimenting with it. Try the following options with a subject of your choosing.

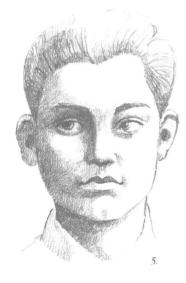

5. Lit from above and to one side. The lighting evident bere is fairly standard. The shadows created define the face in a fairly recognizable way.

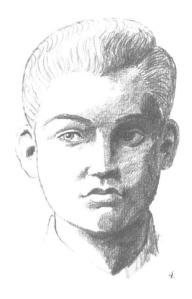

4. Lit directly from the side. Here, half of the face is in shadow and the other half is strongly lit.

As this series of images shows, directional lighting can make an immense difference to a face. The same principles apply equally to figures and objects. Experiment for yourself, using a small lamp or candles. Place objects or a subject at various angles and distances from a light source and note the difference this makes. When you have an effect that interests you, try to draw it.

techniques

ACTION FOR DRAMA

Drama in art can be conveyed through the action of figures. The quality of the composition depends on the way the figures move across the surface of the picture. In these two examples dramatic action is shown in two different ways: in the Picasso by the distortion of shape and in the Castagno by exaggeration of movement.

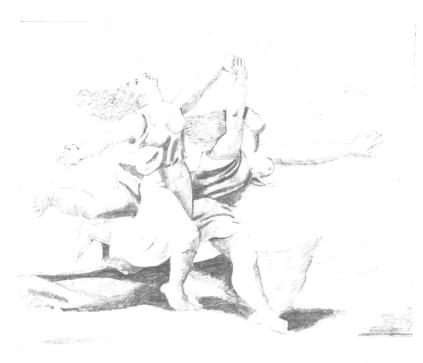

Picasso's figures on a beach are not naturalistically correct. They express the joy of running through the arrangement of the arms – outstretched and linked – and the disjointed leg of the leading figure which stretches out distortedly to suggest the borizontal movement of running.

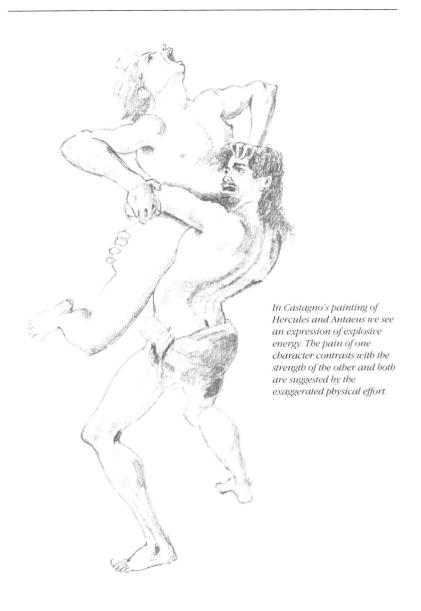

THE GENIUS OF SIMPLICITY

We come full circle with these two copies of paintings by Matisse. Both examples are tutorials in great draughtsmanship: keen observation, the simplification of shapes and the absolute supremacy of line over detail.

Copying any of the great masters teaches us that great art can not be reduced to a formula and simply emulated. The observation of life and the attempt to draw honestly what you see, each time, freshly, is the way to produce good drawings.

Matisse's original of 'Carmelina' was painted very simply to create solidity, and this pencil drawing of it imitates his solid, chunky technique. Because the figure is lit very strongly from the side, you will notice clear-cut shadows and brightly lit areas.

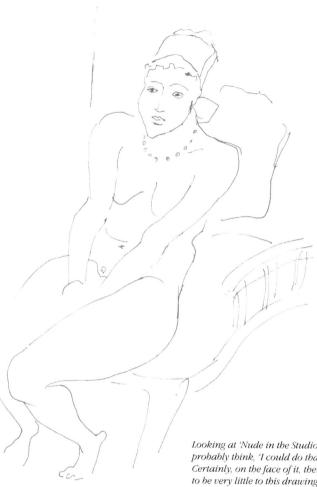

Looking at 'Nude in the Studio' you will probably think, 'I could do that.' Certainly, on the face of it, there appears to be very little to this drawing and some parts look to be crudely drawn. Get a copy of the original and try it for yourself.

When you've tried to draw in this way, you'll know how difficult it is. It is so easy to do too much and in the process lose the truth of what you are trying to portray.

AIDS TO BETTER DRAWING

For the newcomer who wants to learn to draw, the pitfalls can sometimes seem insuperable. I see this time and again in the classes I teach, both with adults and young people. Drawing can get tough for a number of reasons and there is no magic wand a teacher can use to wave them away. In actuality the problems are few, and some of them arise out of the student's own misconceptions and anxieties. Here are a few points to remember.

- You get good at what you practice. It is always possible to improve. Talent is useful, but desire, determination and intelligence will get you much further.
- The exercises provided in the First Stages section are essential practices which cannot be repeated too often. All of them have been exhaustively practised by myself, and have proved to be very useful in terms of improving my levels of perception and confidence. No matter where you are starting from, these practices are important. Don't be too proud to re-visit them when you are having problems with your drawing. A good technique gives confidence which is vital if you want to draw well.
- Tackle difficulties one at a time. As soon as you see something that is obviously incorrect, work to put it right. Artists gain confidence from the knowledge that if they can put one problem right, it must be possible to put all the other problems right. By correcting one type of error, you will find that other areas of your work tend to improve as well.
- Try not to get tense or angry when your efforts don't seem to be bearing fruit. Don't concern yourself with the idea of producing 'beautiful drawings'. Just keep correcting. Aim for accuracy, and let the beauty of your work look after itself.
- Look at as many works by other artists as you can. If you have contact with a living artist, study his work and watch him draw if he will allow you to. You can learn very much more quickly like this. If you are serious about becoming an accomplished artist, you will eventually have to find a teacher to work with.
- Don't throw away any of your work immediately. It is always difficult to see a recently completed drawing objectively. A year later you can see exactly how good it is and whether to keep it or not. For the beginner, keeping work is important for another reason. It is tremendously satisfying to see some improvement. Bit by bit, if you persevere, your drawings will improve. You can check this out for yourself by putting aside early drawings and not looking at them for several months until you feel you have done some real work. If you then place one of your early drawings against a current one, I bet you'll see a big difference.
- Finally, a tip for when you decide to try painting and use colour. Remember this: painting is
 only drawing with colour, and the 'language' you have learnt in this book will still apply.

Once you get into drawing, you will find it adds a whole new quality to your life. After you have been practising for a while, you will actually begin to see the world differently. For an artist, the visual world is full of interest, and what he sees is life-enhancing. Shapes, colours, light, shade, movement – all these elements go into making this world a feast of experience. I hope by this stage you have gained a sense of this richness and that it will carry you forward and encourage you to keep practising and keep experimenting. Good luck.